1/29/16

I ♥ COLORING FLOWERS

PSS!
PRICE STERN SLOAN
An Imprint of Penguin Random House

PRICE STERN SLOAN
An Imprint of Penguin Random House LLC

Additional material adapted from www.shutterstock.com.
Copyright © 2015 by Buster Books. First published in the
United States of America in 2015 by Price Stern Sloan, an
imprint of Penguin Random House LLC, 345 Hudson Street,
New York, New York 10014. *PSS!* is a registered trademark of
Penguin Random House LLC. Printed in Canada.

ISBN 978-0-399-54130-8 10 9 8 7 6 5 4 3 2 1

Illustrated by

Lizzie Preston and Jane Ryder-Gray

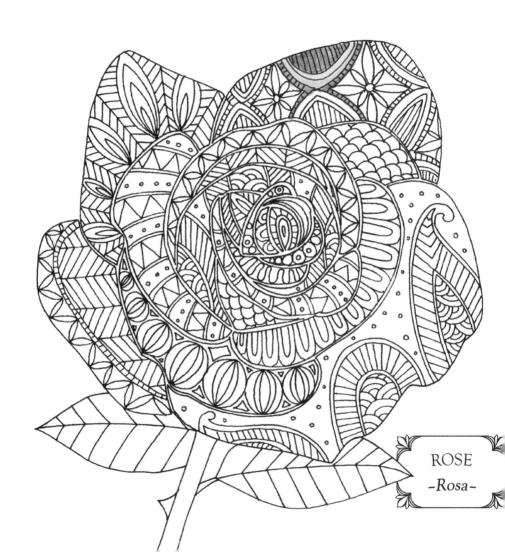

ROSE
-Rosa-

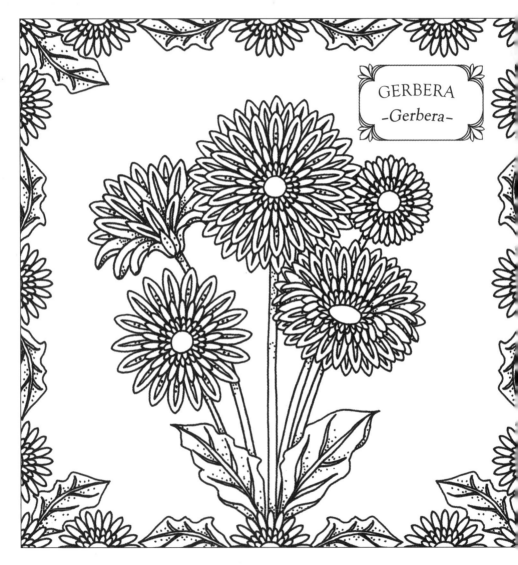

GERBERA

-*Gerbera*-

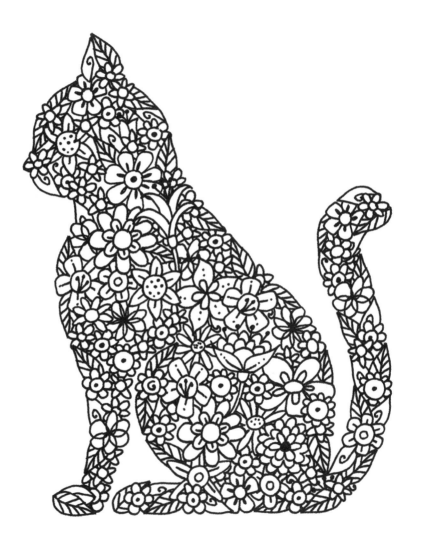

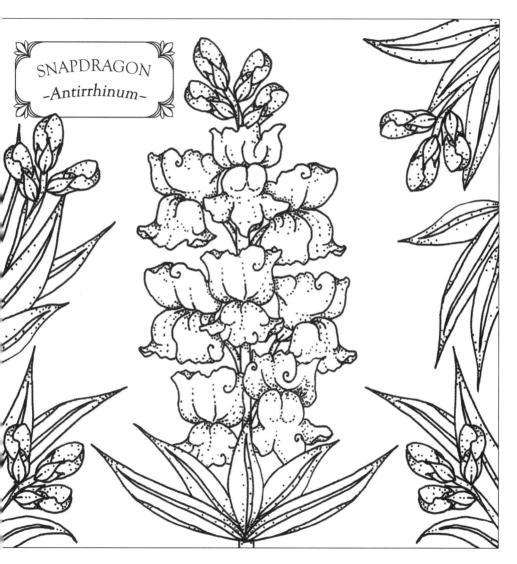

SNAPDRAGON

-Antirrhinum-

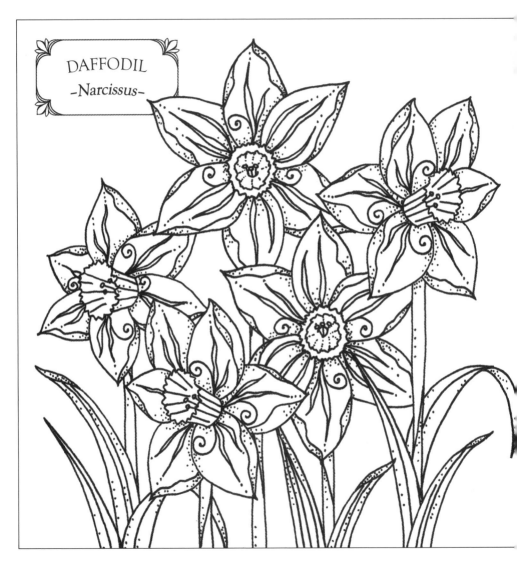

DAFFODIL
-Narcissus-

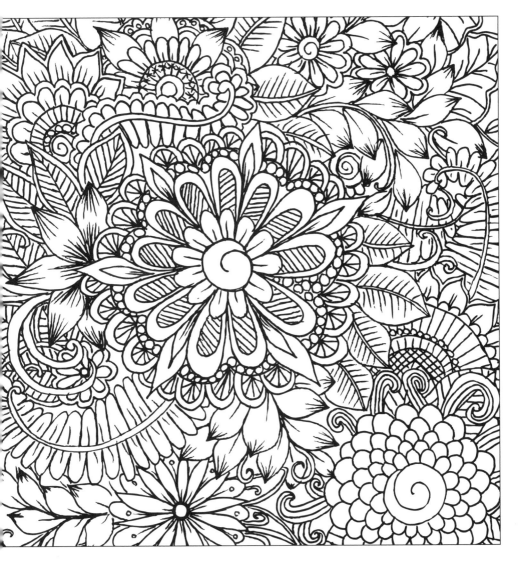

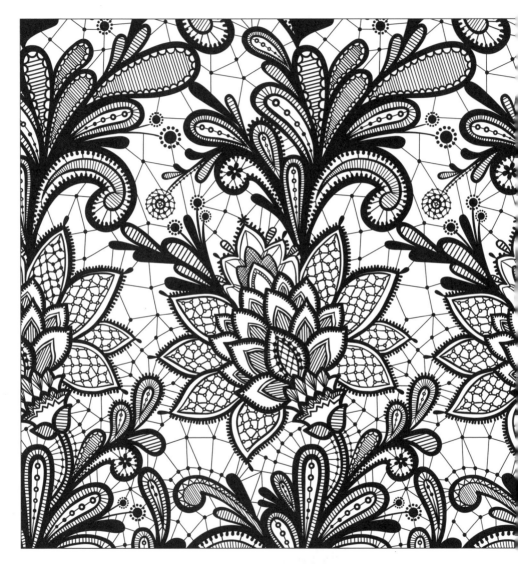

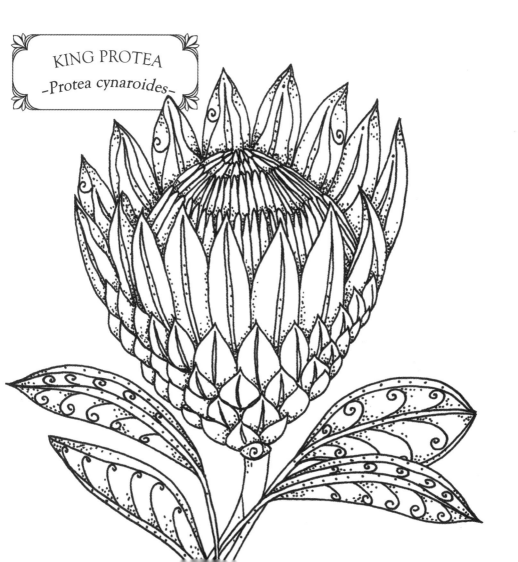

KING PROTEA

-Protea cynaroides-

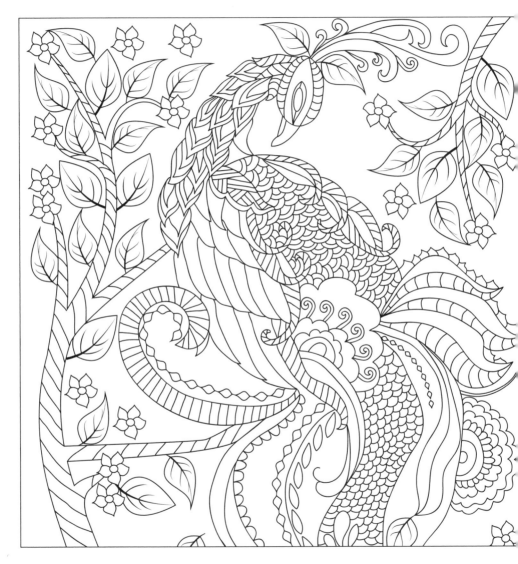

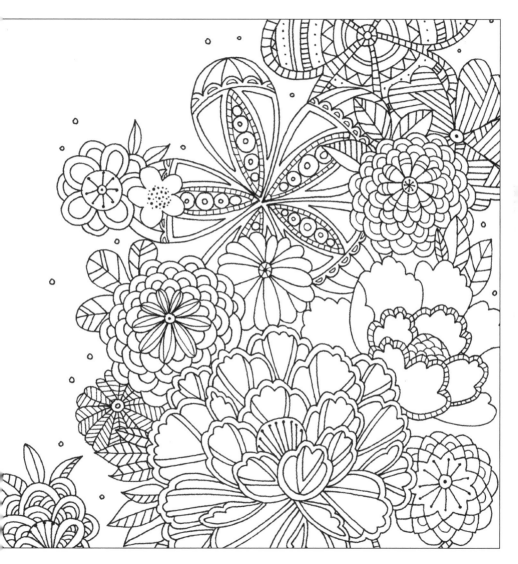

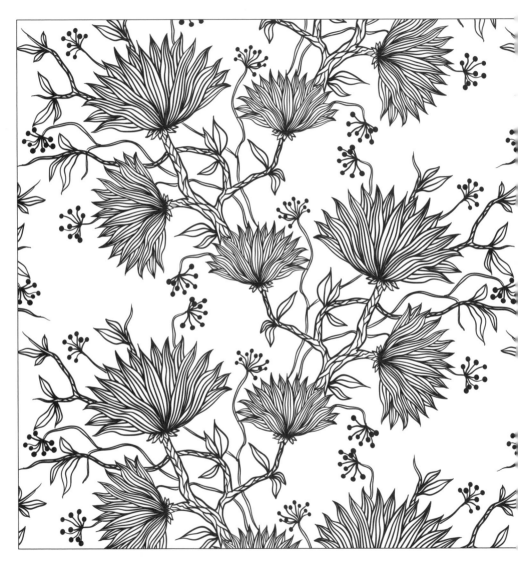

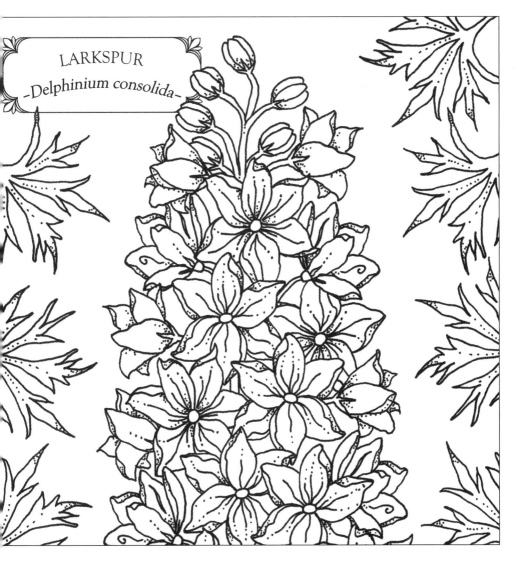

LARKSPUR

-Delphinium consolida-

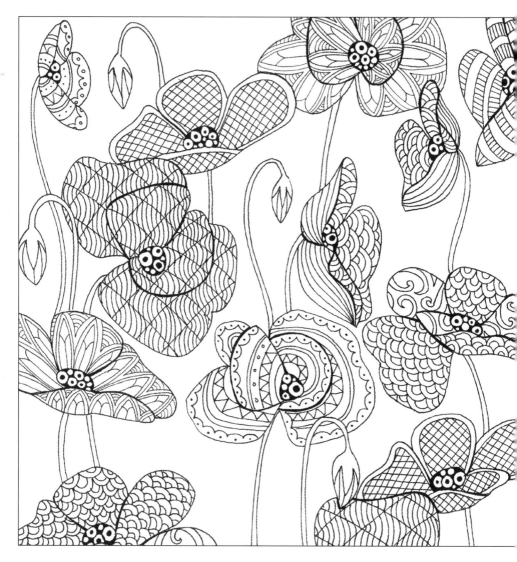

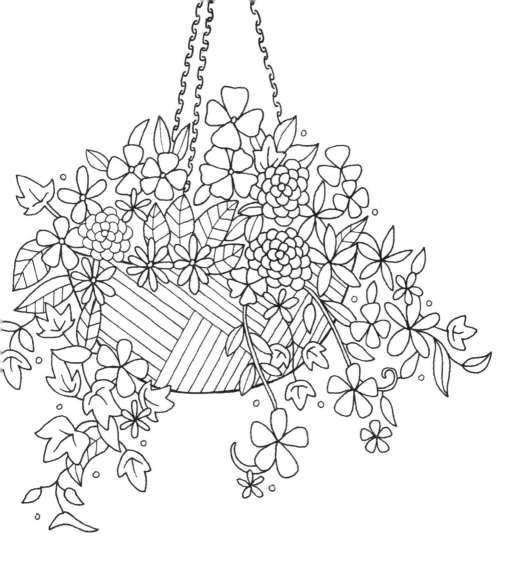

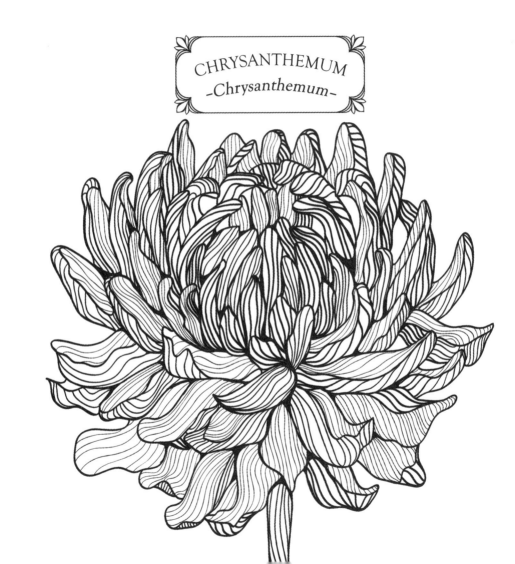

CHRYSANTHEMUM

-Chrysanthemum-

PHEASANT'S EYE
-Adonis annua-

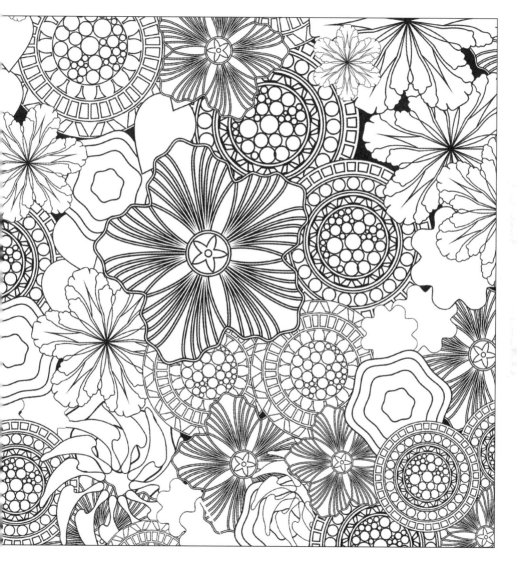

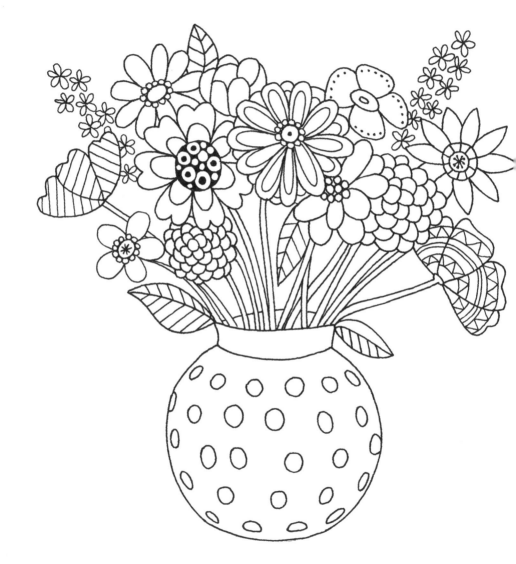

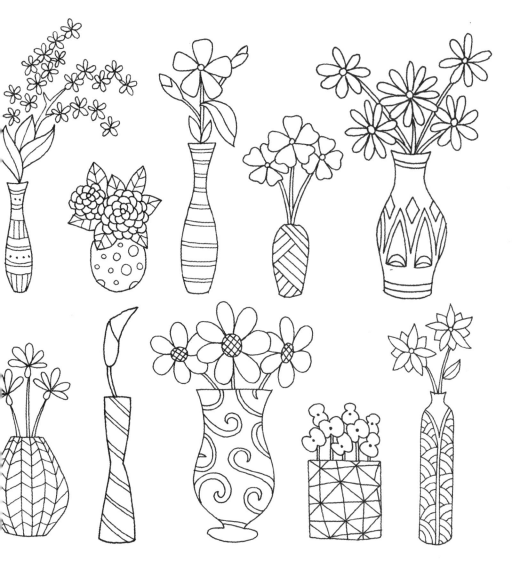

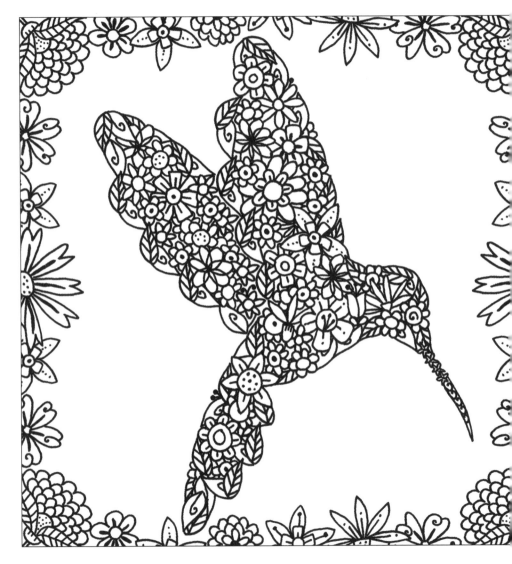

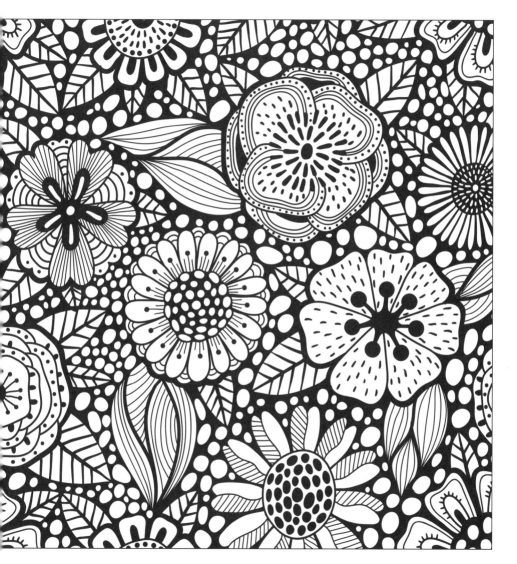

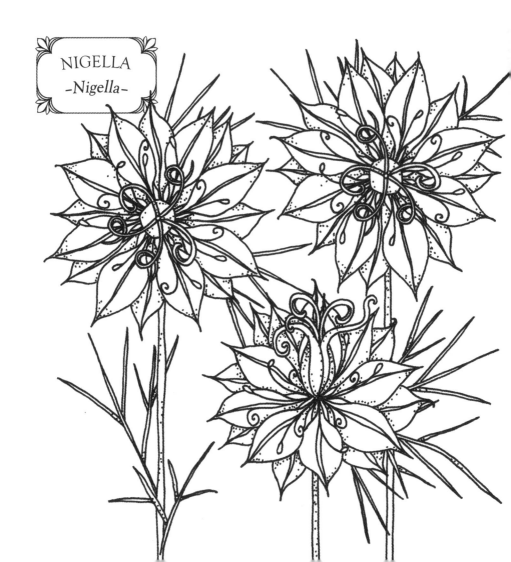

NIGELLA

-Nigella-

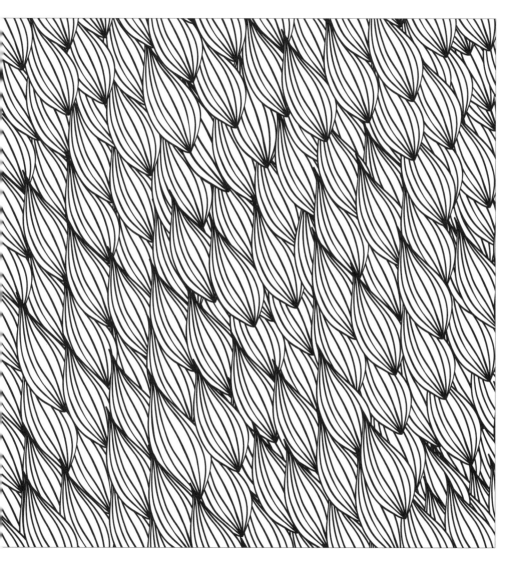

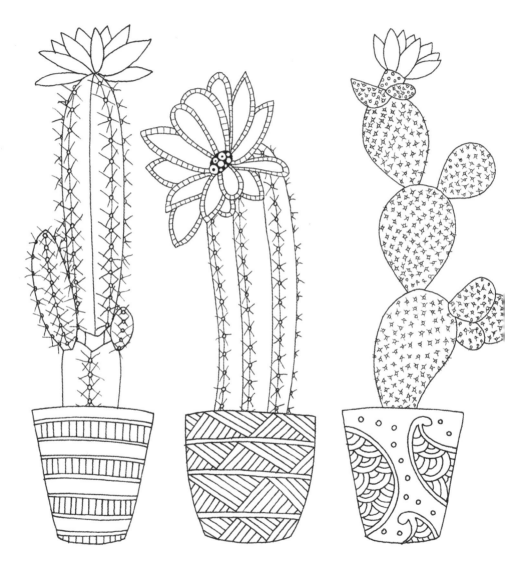

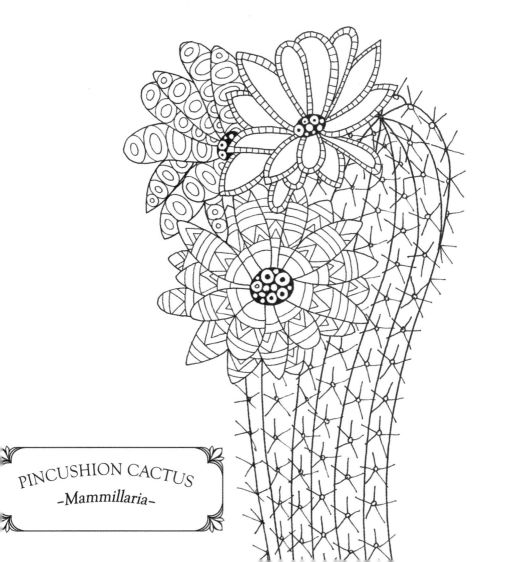

PINCUSHION CACTUS
-Mammillaria-

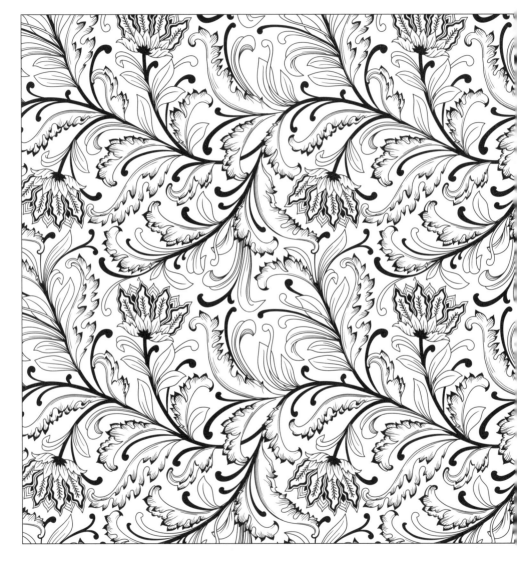

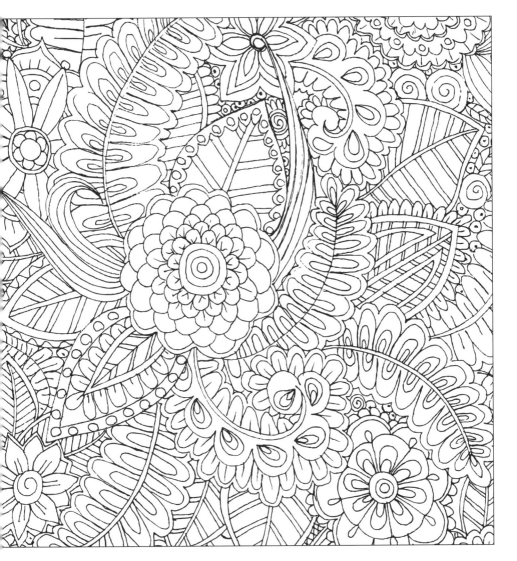

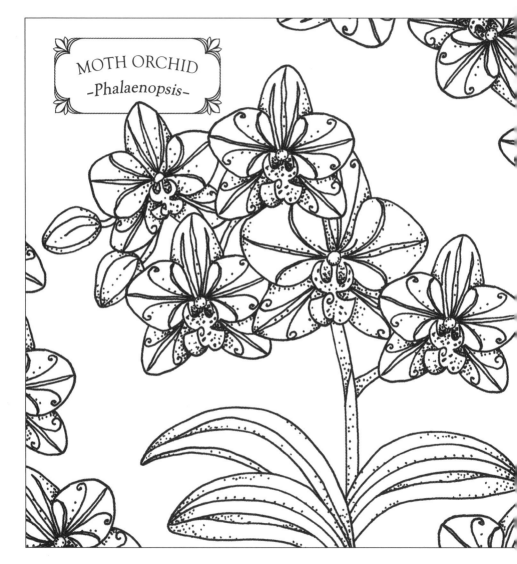

MOTH ORCHID

-Phalaenopsis-

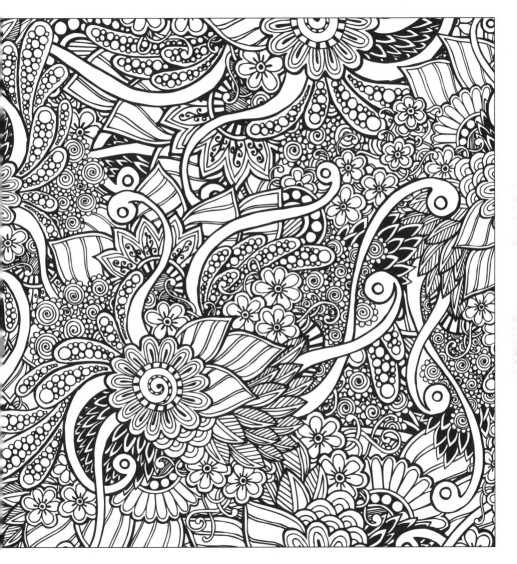

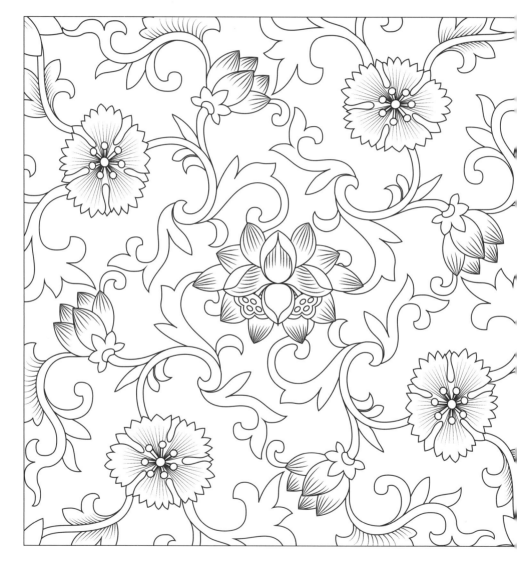

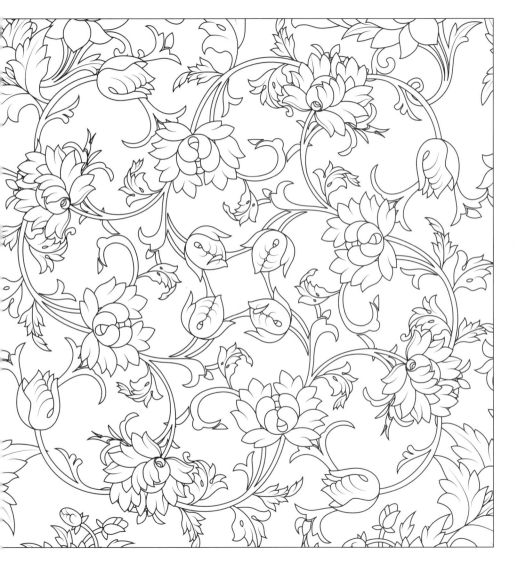

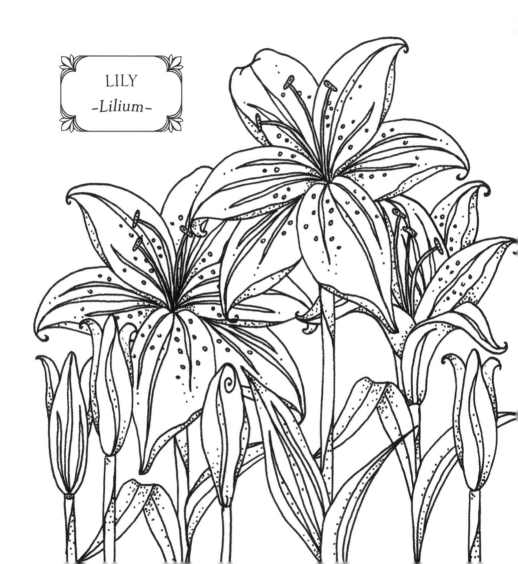

LILY

-Lilium-

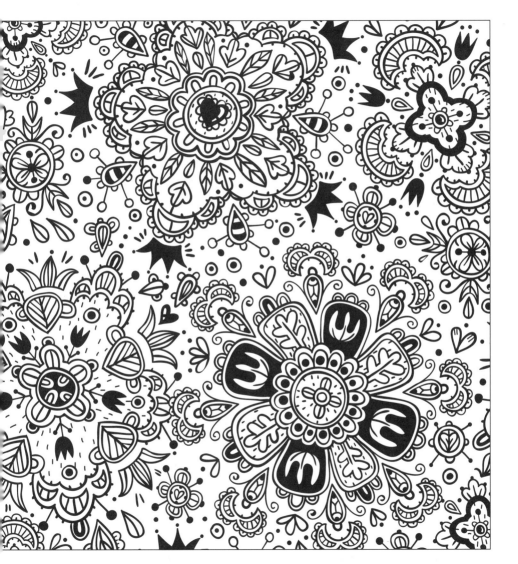

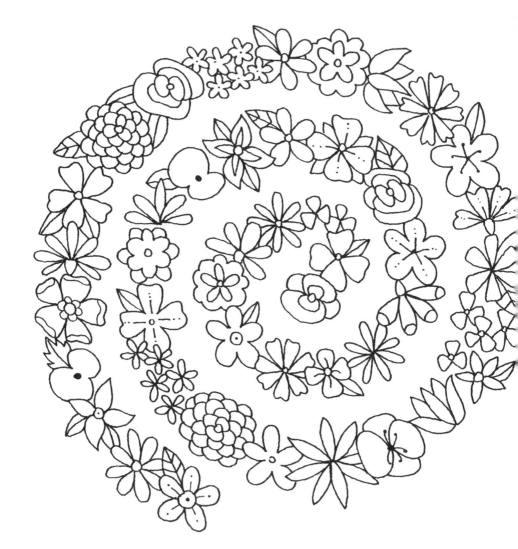

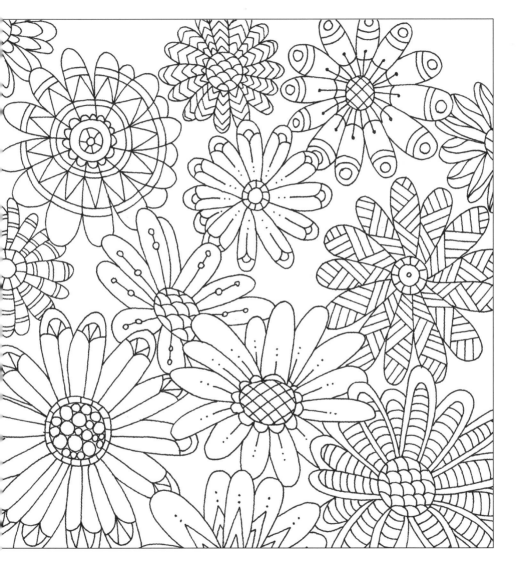

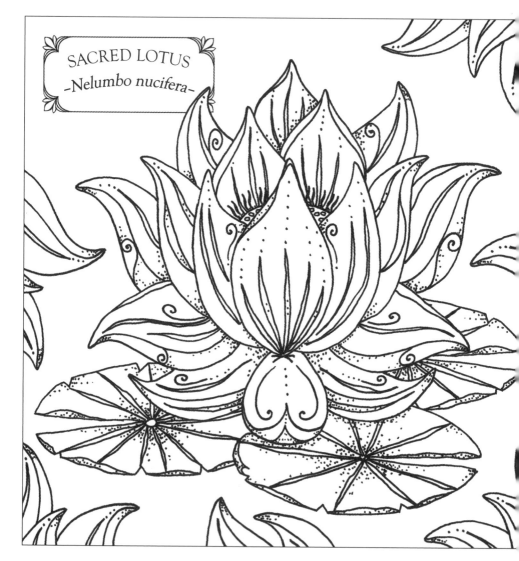

SACRED LOTUS

-Nelumbo nucifera-

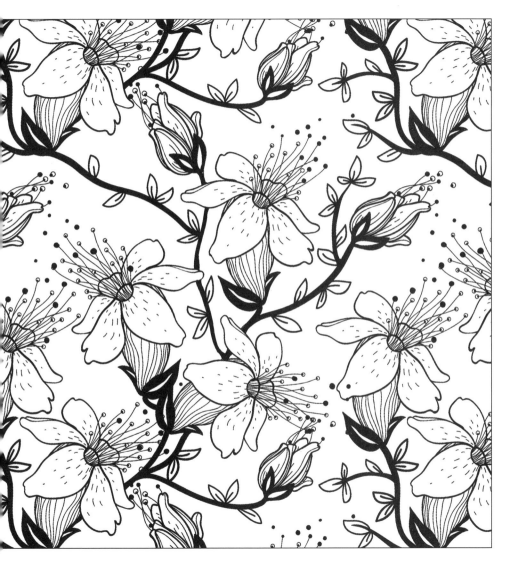

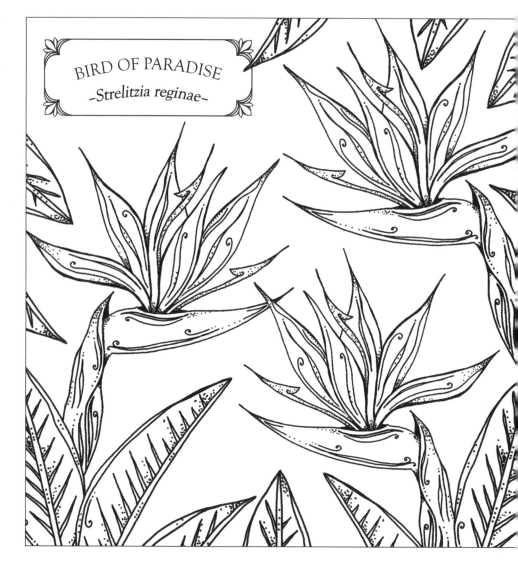

BIRD OF PARADISE
-Strelitzia reginae-

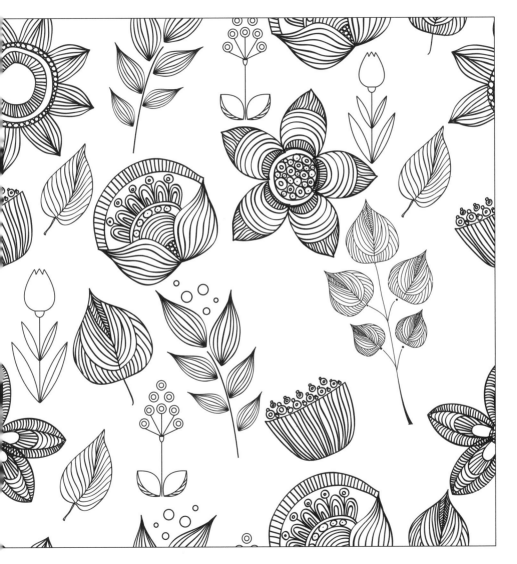

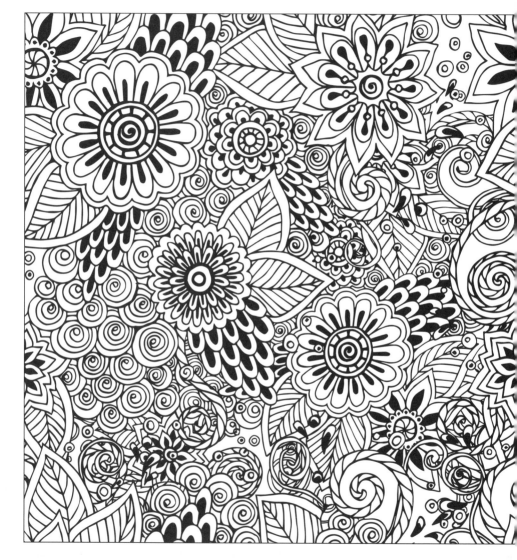

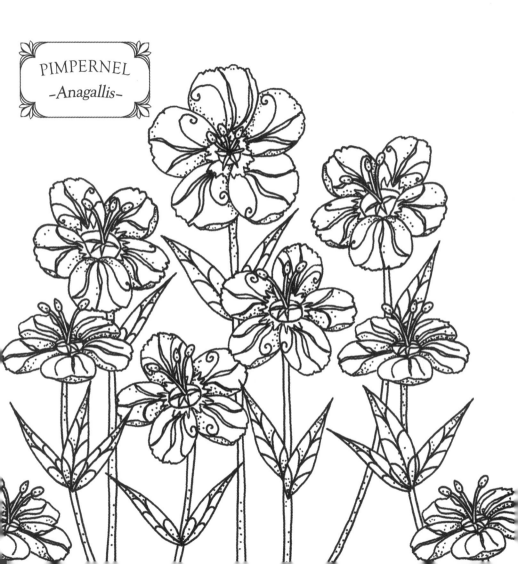

PIMPERNEL

-Anagallis-

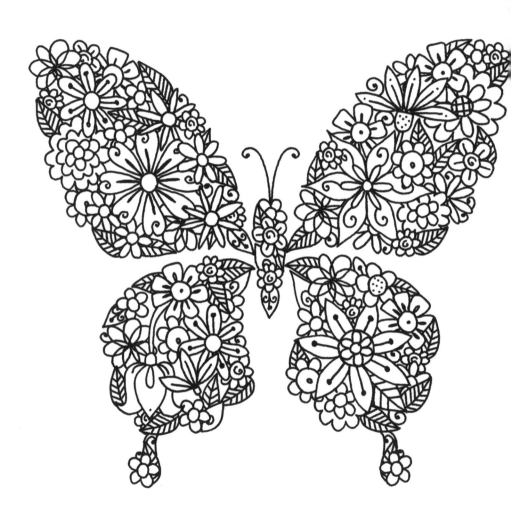

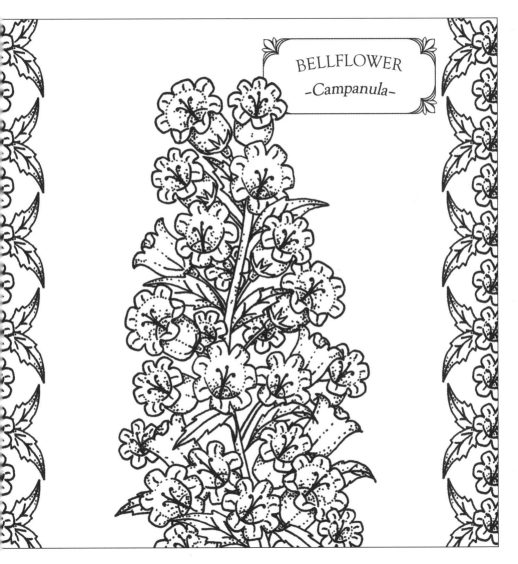

BELLFLOWER

-Campanula-

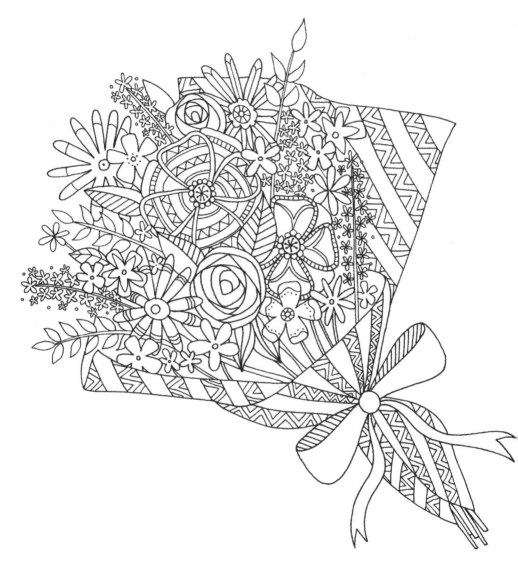

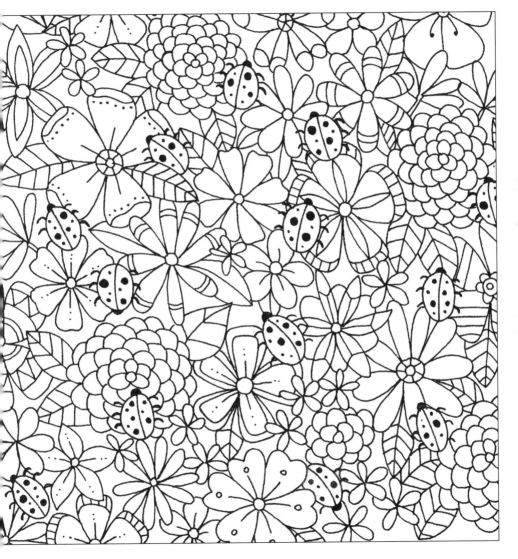

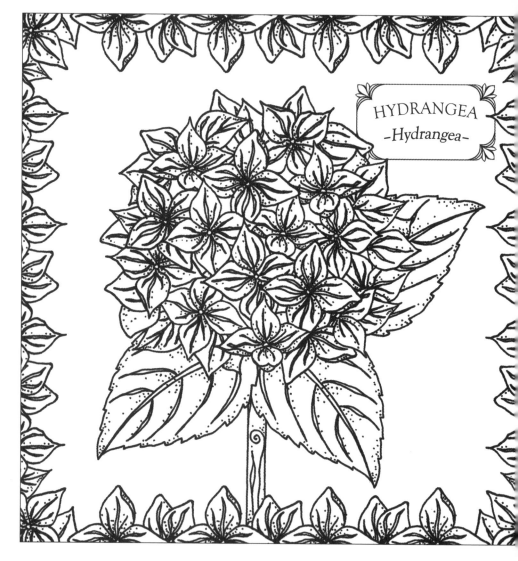

HYDRANGEA
-Hydrangea-

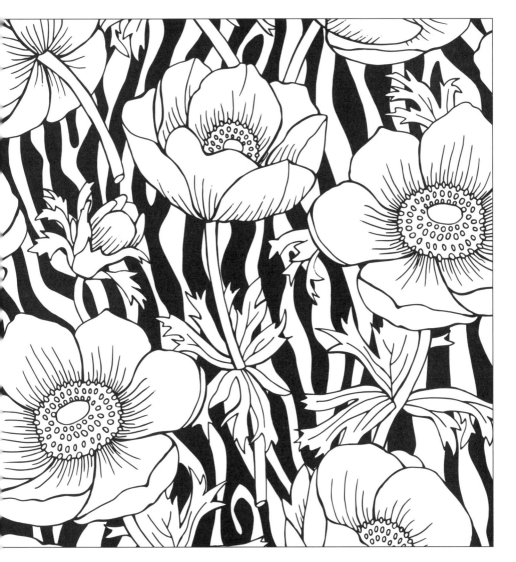

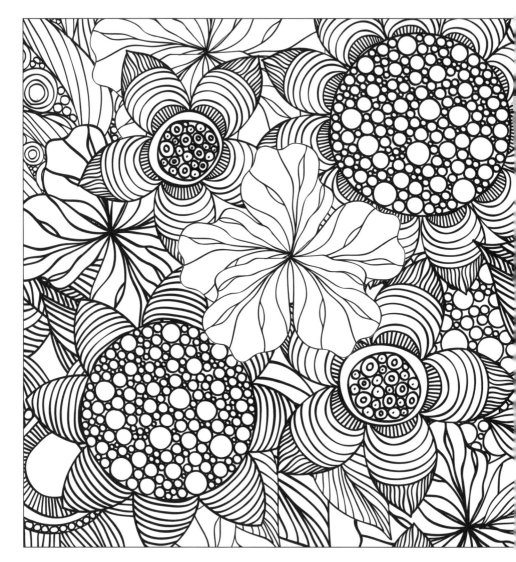

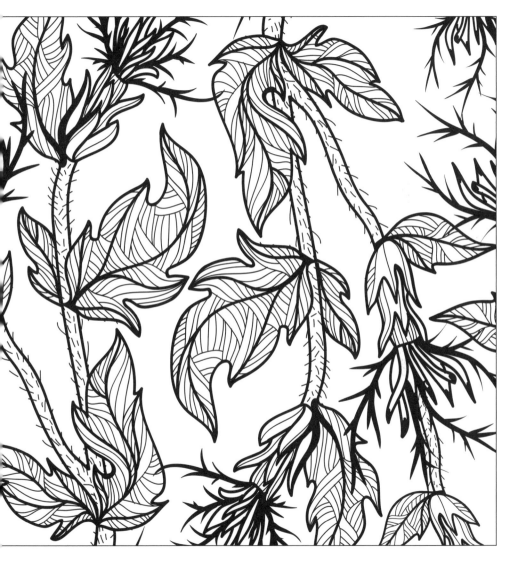

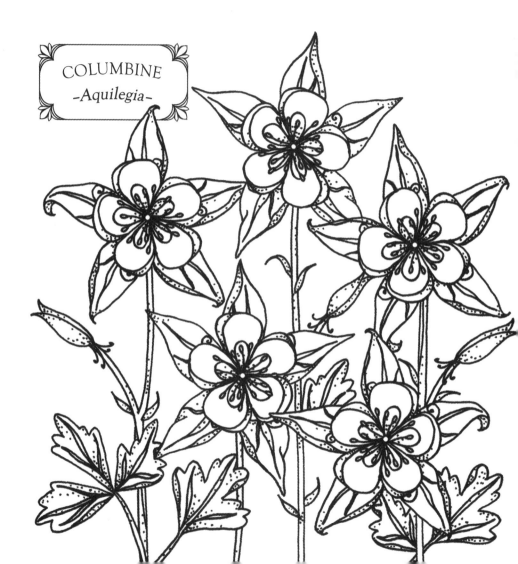

COLUMBINE

-Aquilegia-

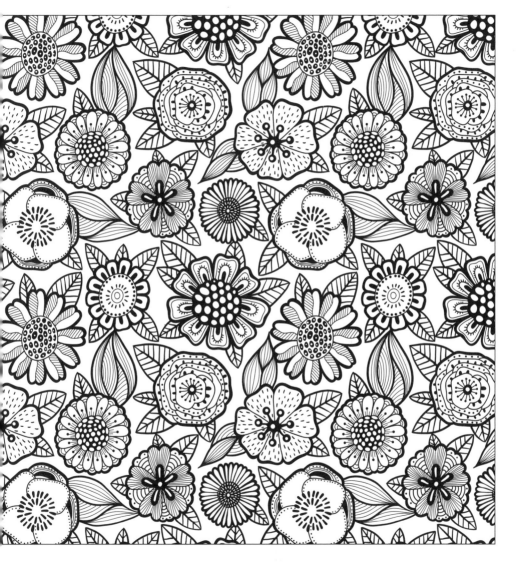

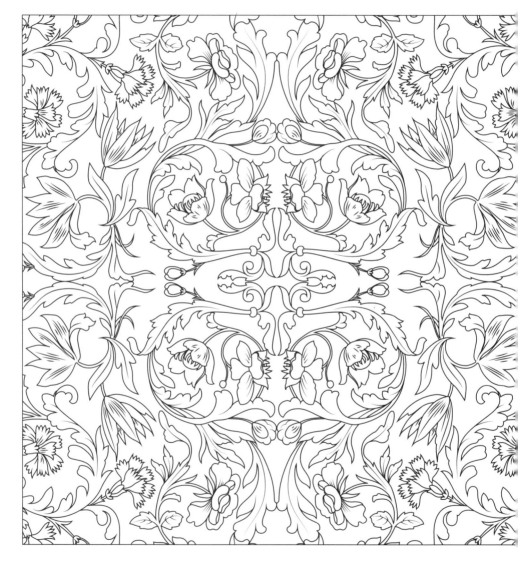

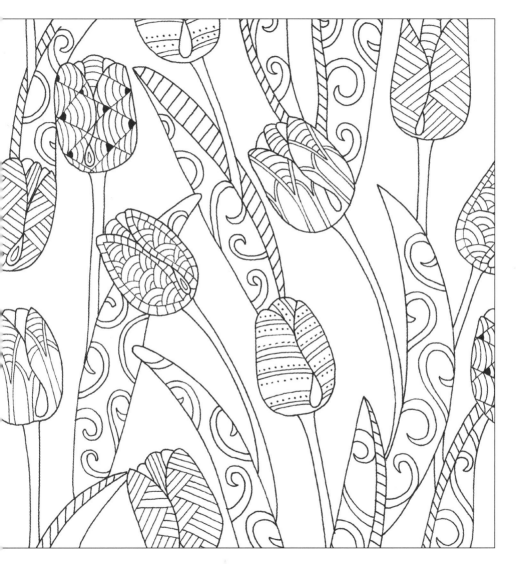

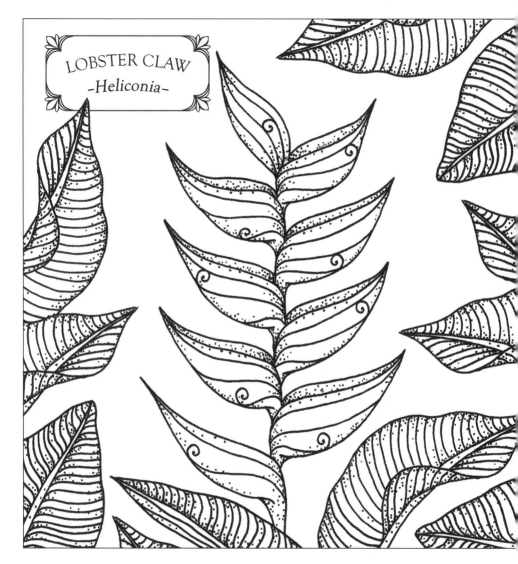

LOBSTER CLAW
-Heliconia-

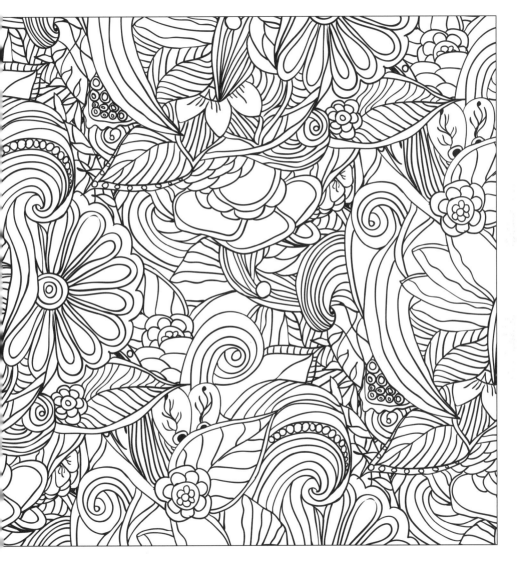

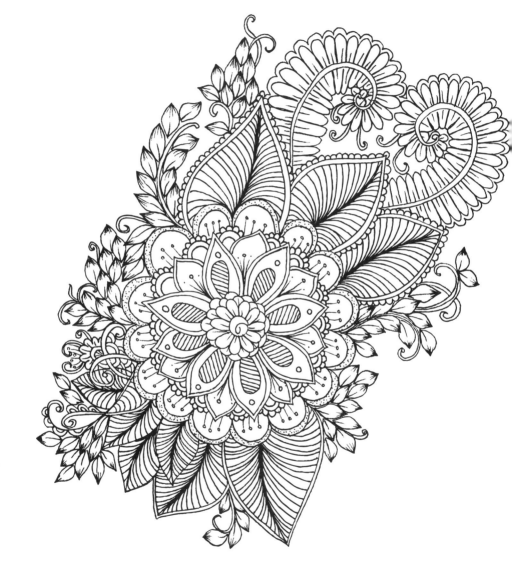

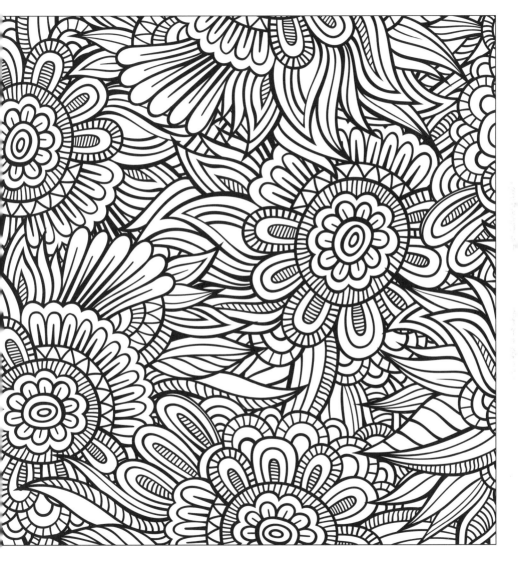

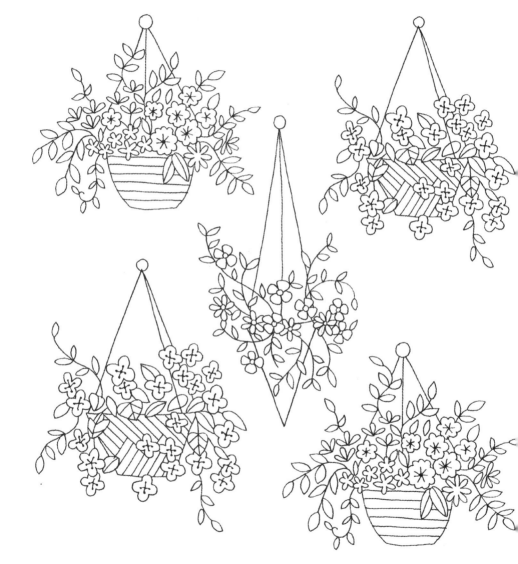

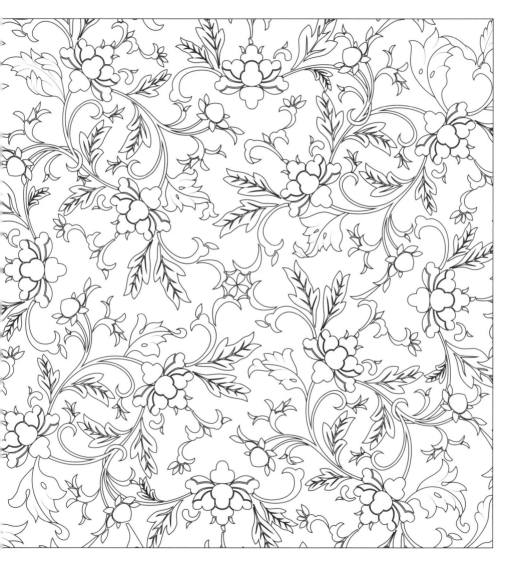

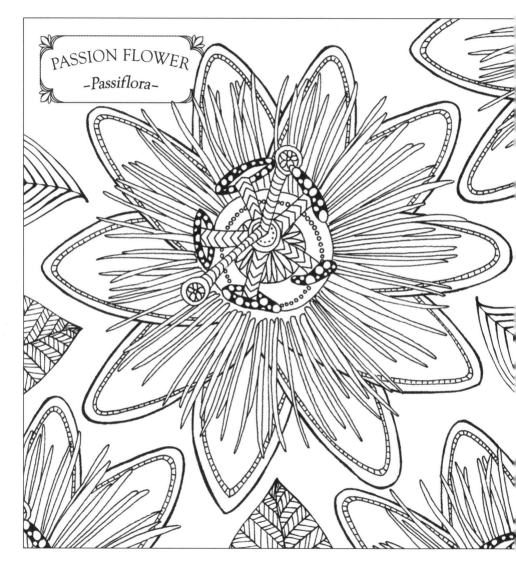

PASSION FLOWER
-Passiflora-

PERSIAN BUTTERCUP
-Ranunculus asiaticus-

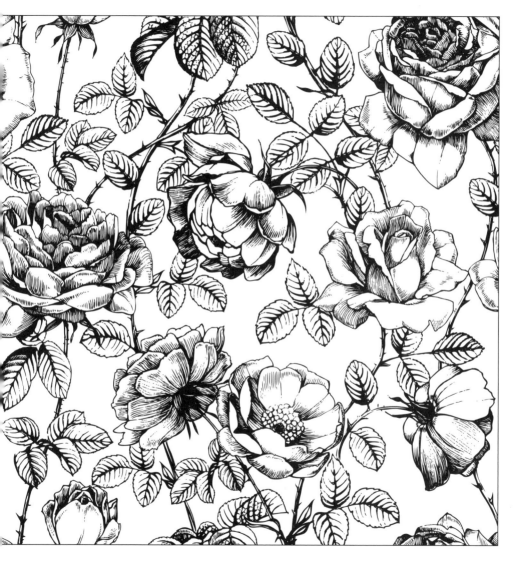

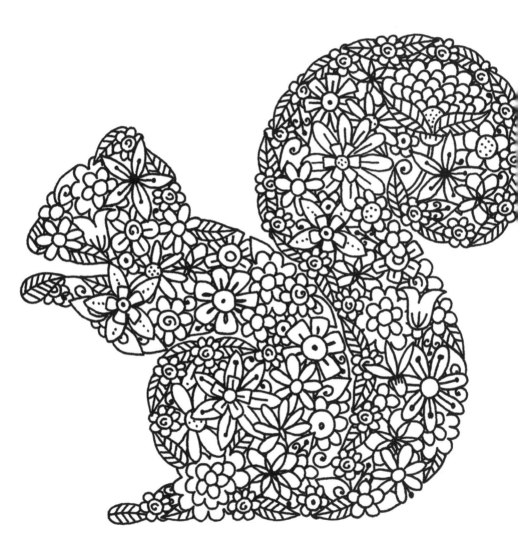

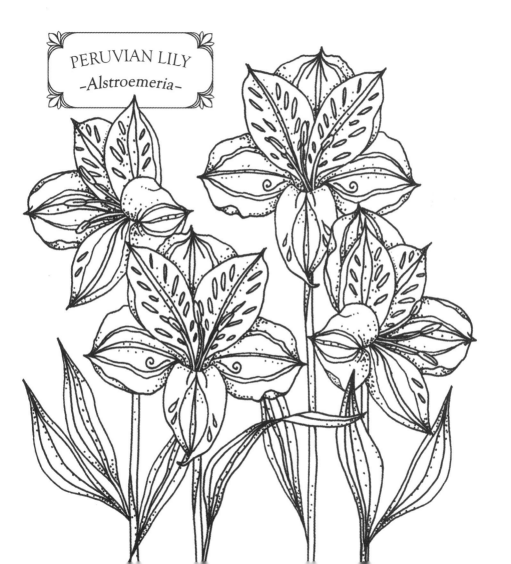

PERUVIAN LILY

-Alstroemeria-

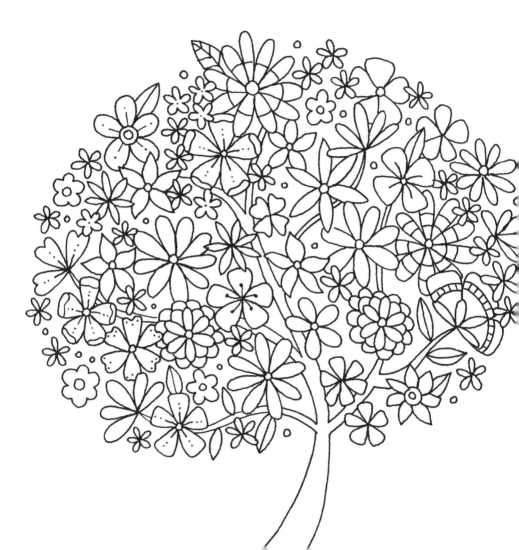

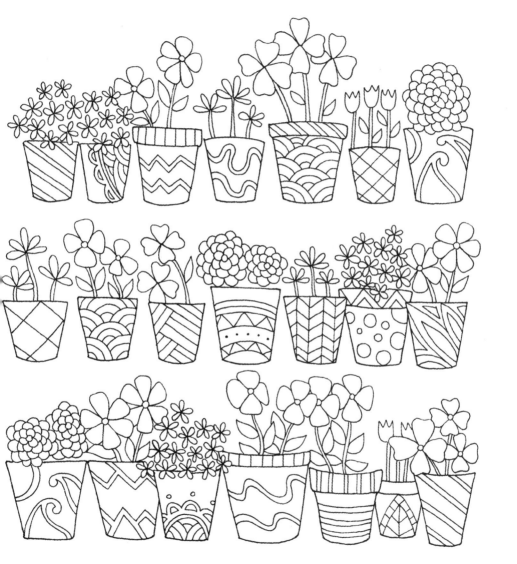

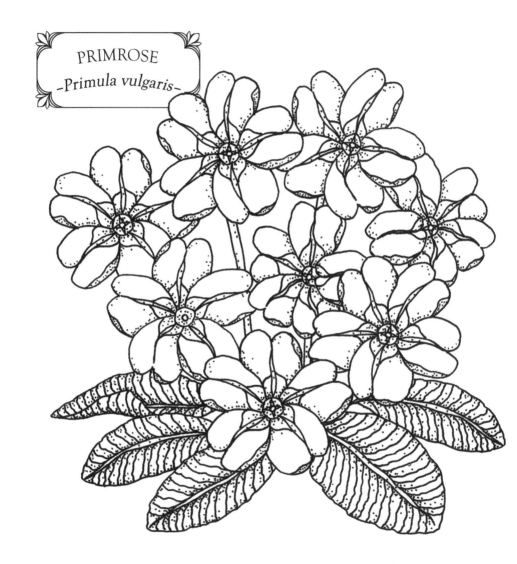

PRIMROSE
-Primula vulgaris-

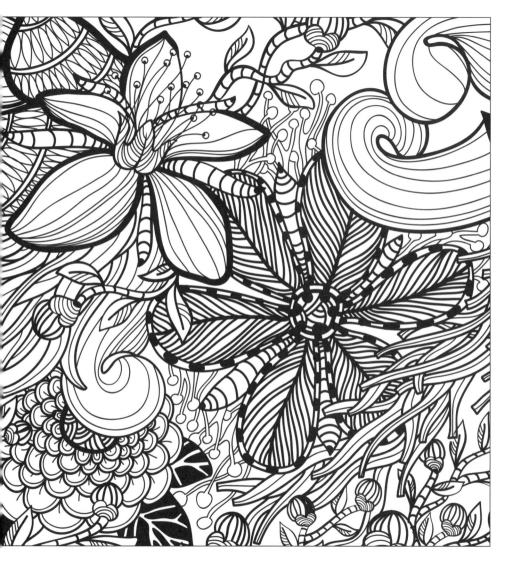

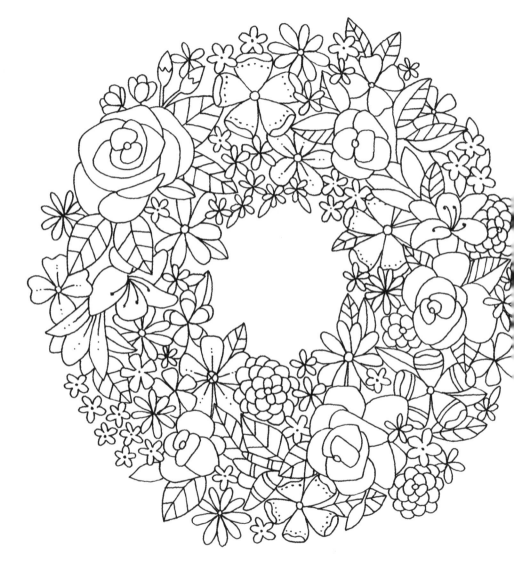

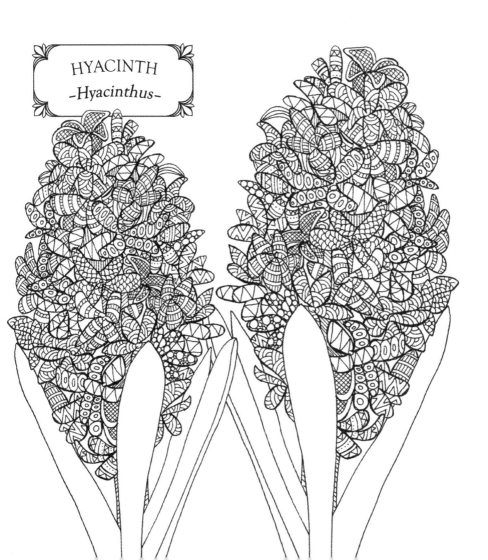

HYACINTH

-Hyacinthus-

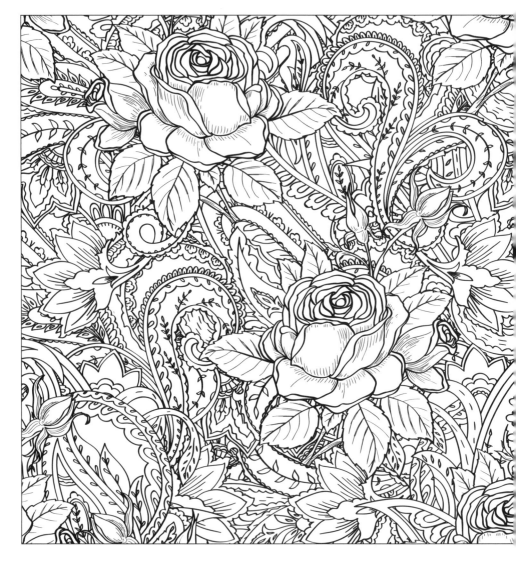

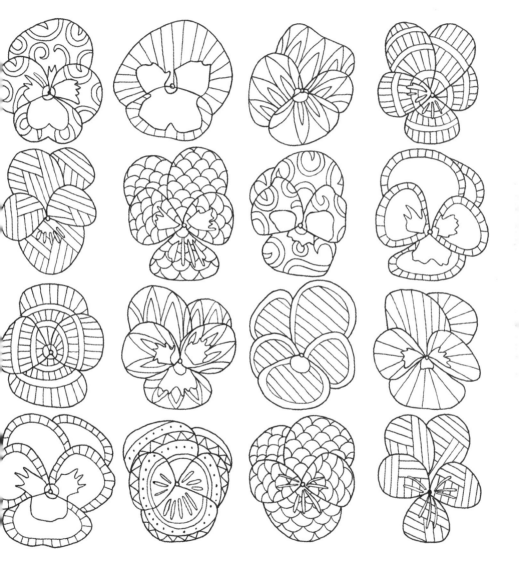

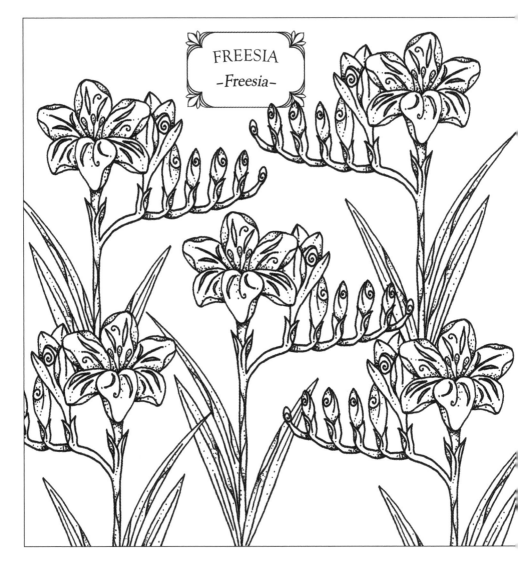

FREESIA
-Freesia-

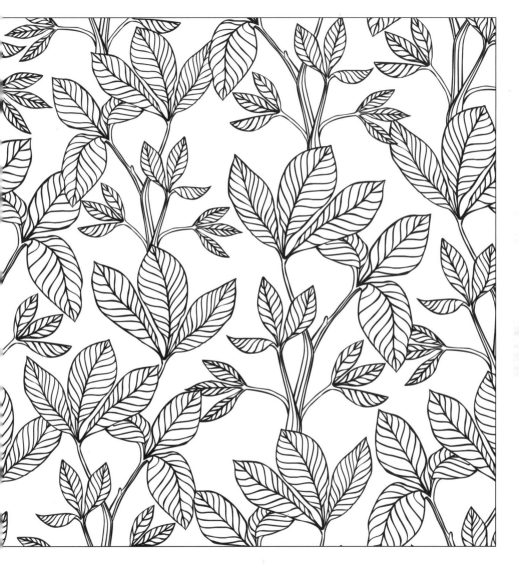

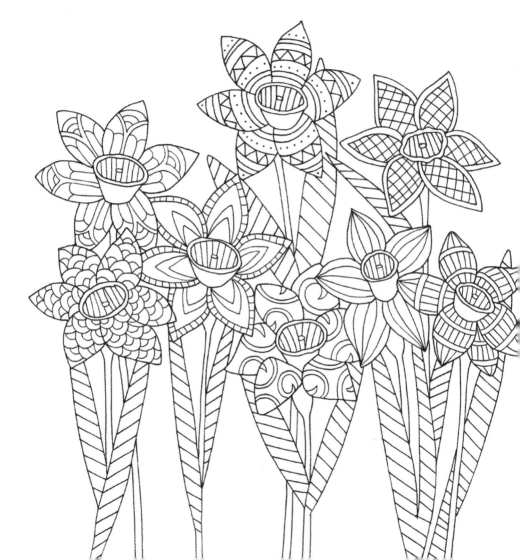

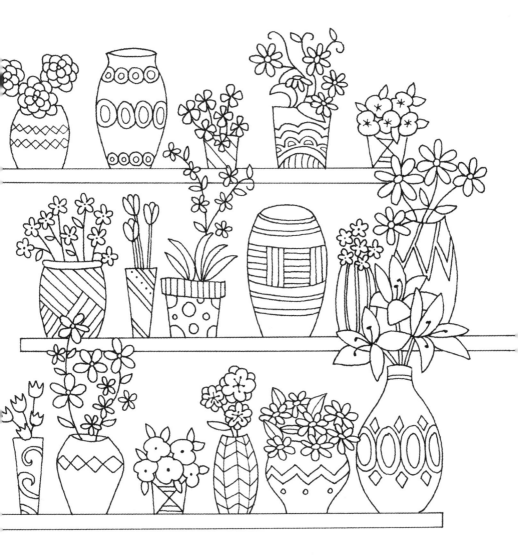

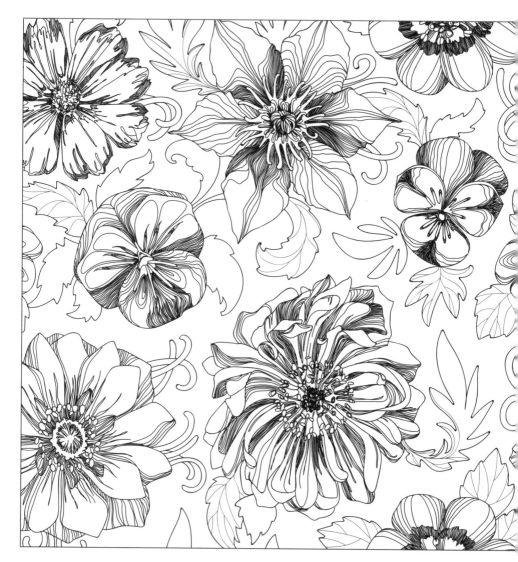

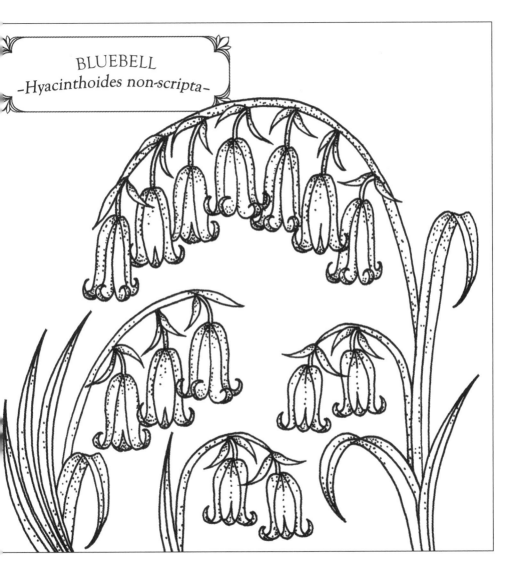

BLUEBELL
-Hyacinthoides non-scripta-

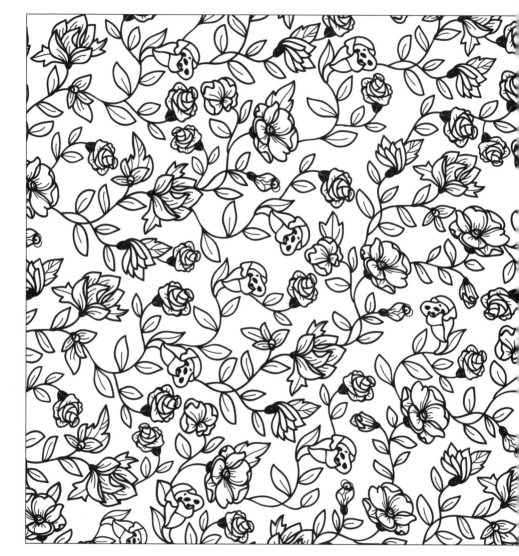

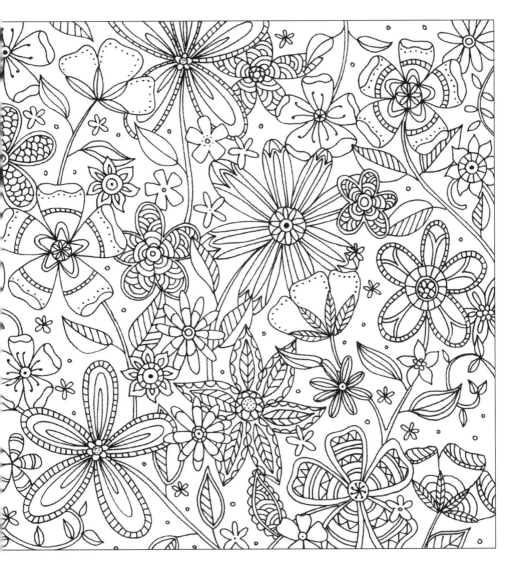

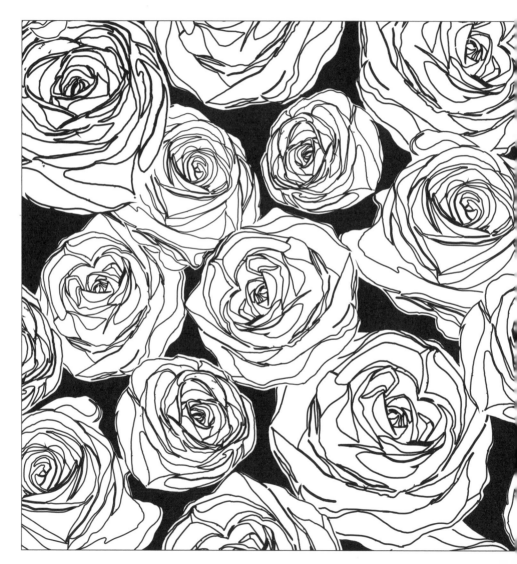

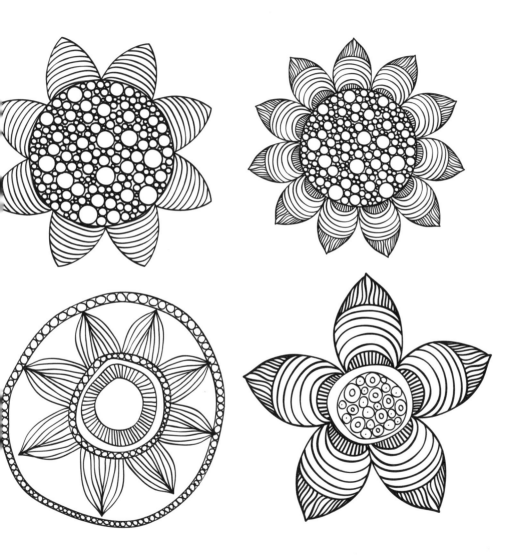

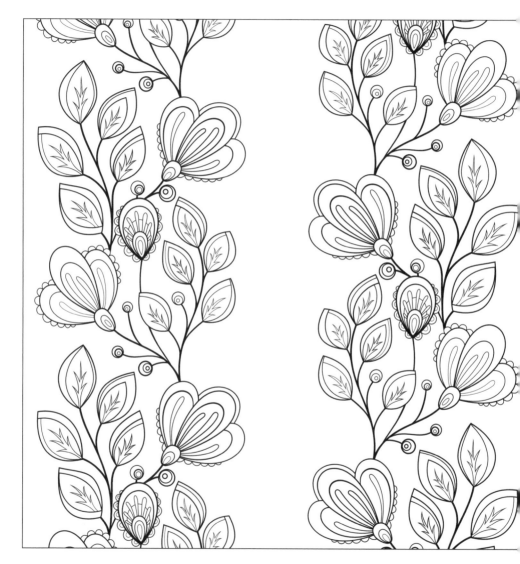

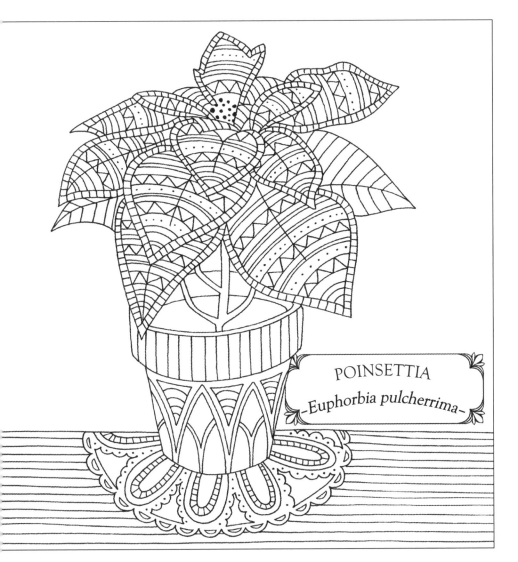

POINSETTIA

-*Euphorbia pulcherrima*-

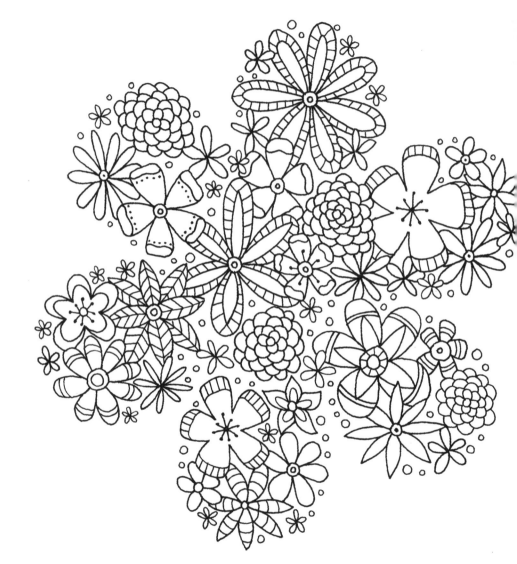

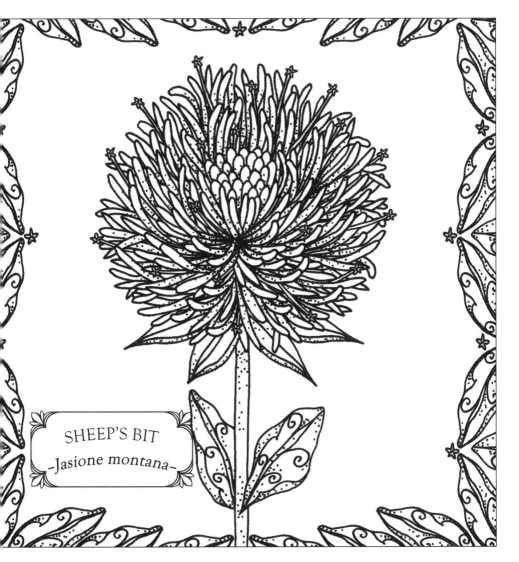

SHEEP'S BIT

-Jasione montana-

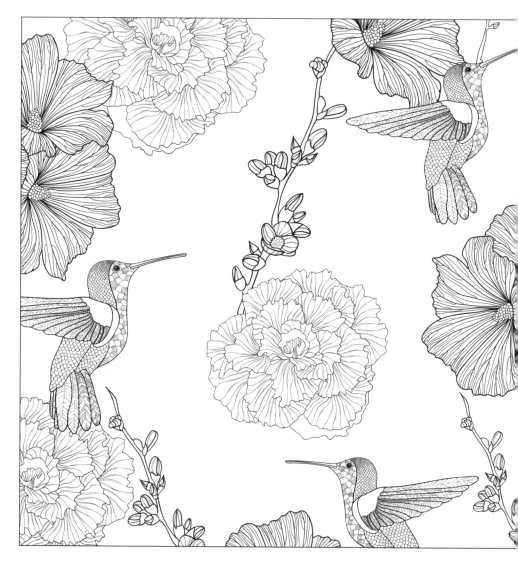

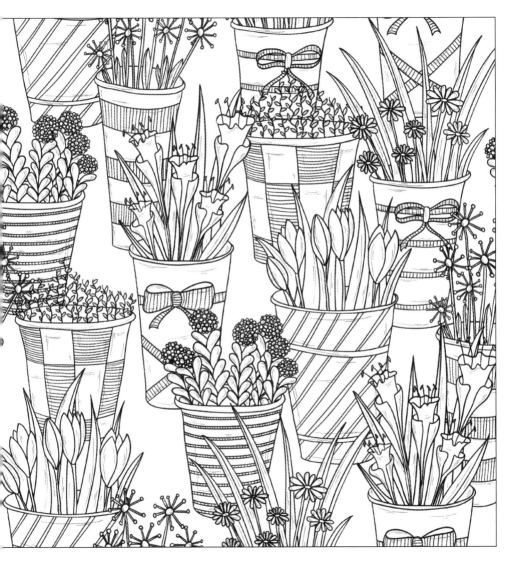

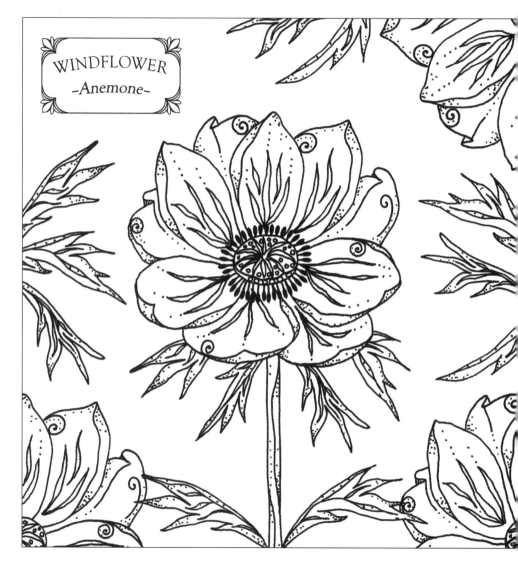

WINDFLOWER
-Anemone-

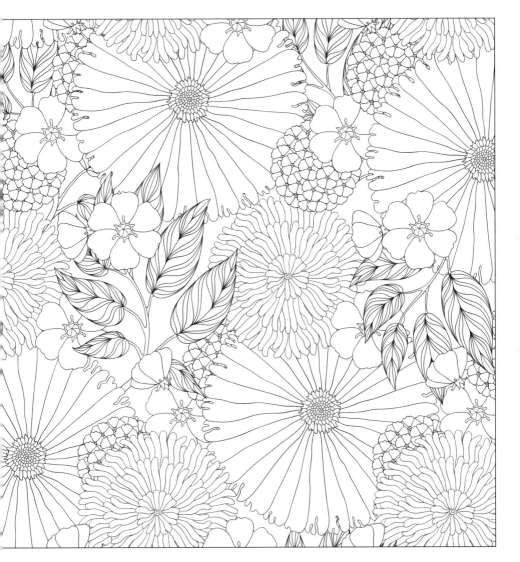

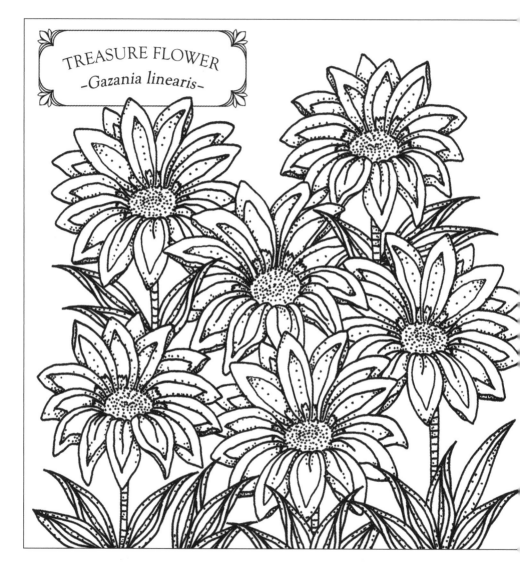

TREASURE FLOWER
-Gazania linearis-

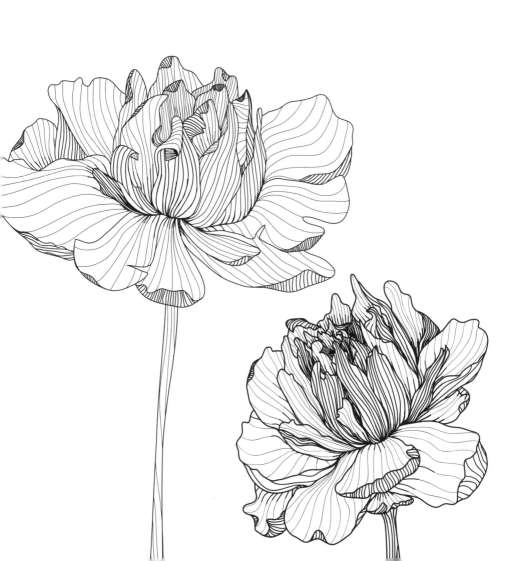

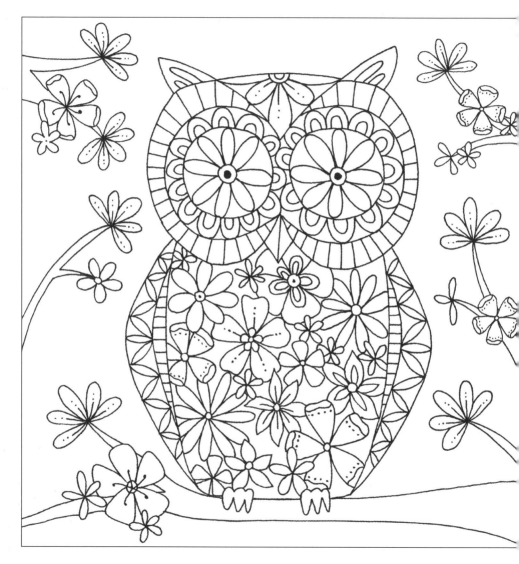

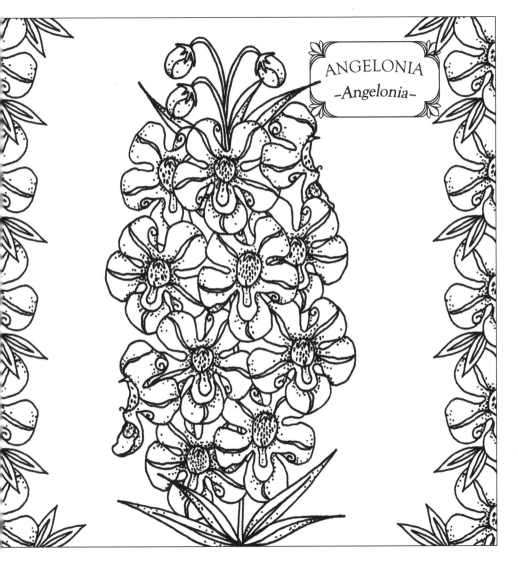

ANGELONIA

-Angelonia-

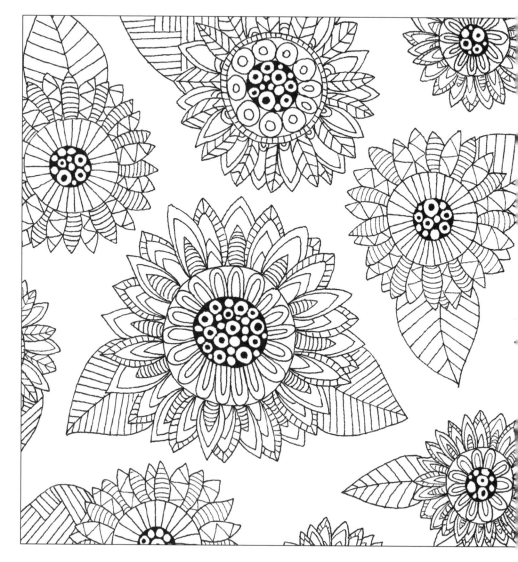

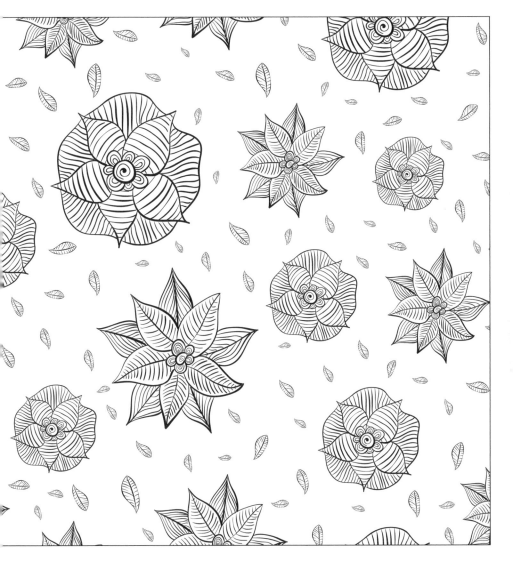

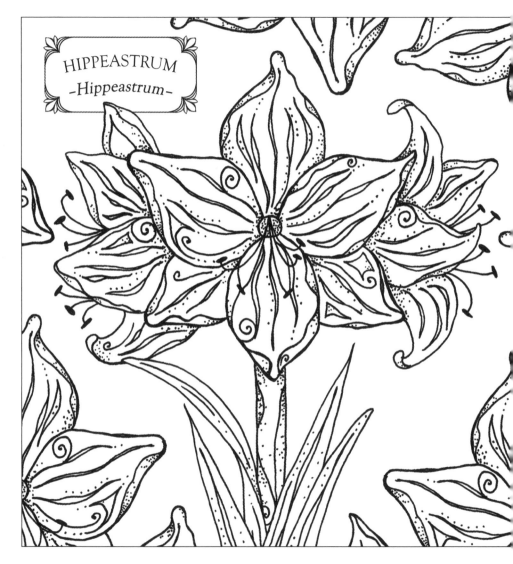

HIPPEASTRUM

-Hippeastrum-

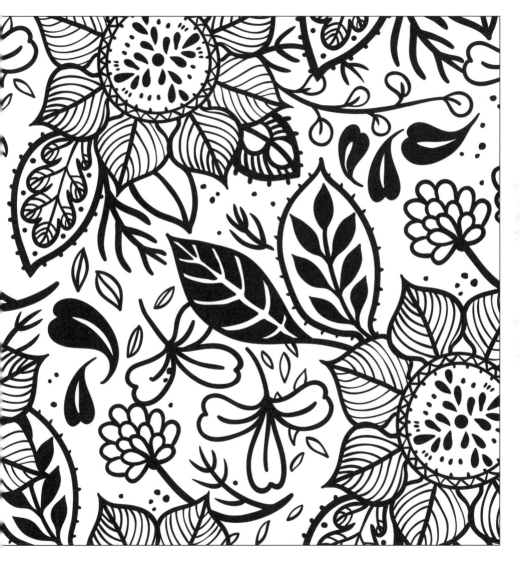

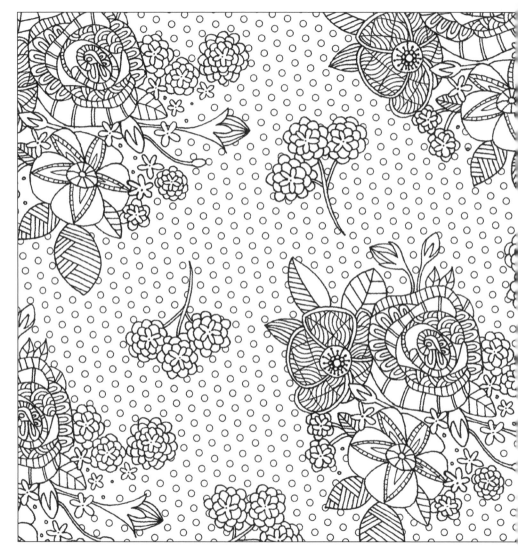

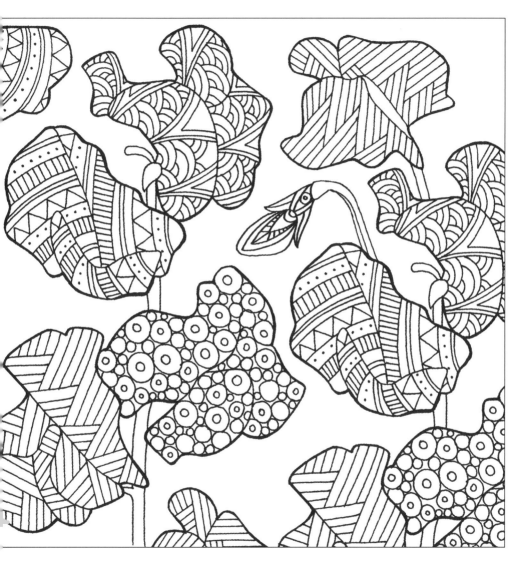

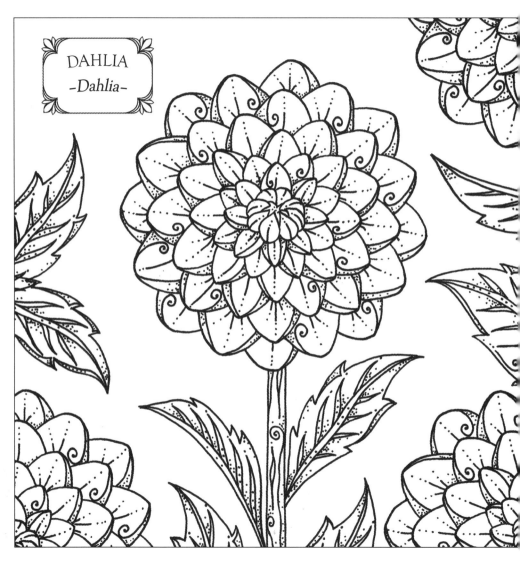

DAHLIA

-Dahlia-

IRIS

-Iris-

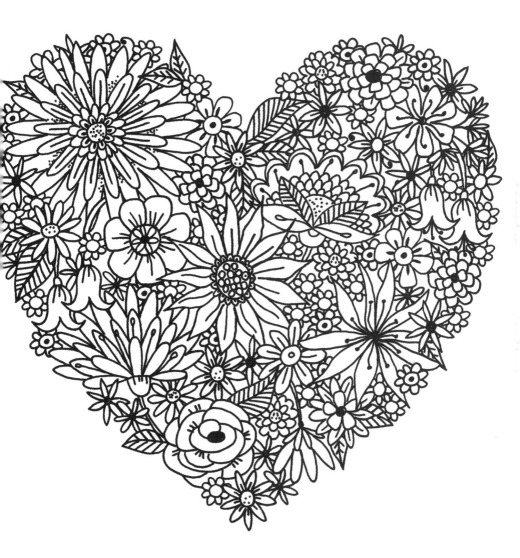

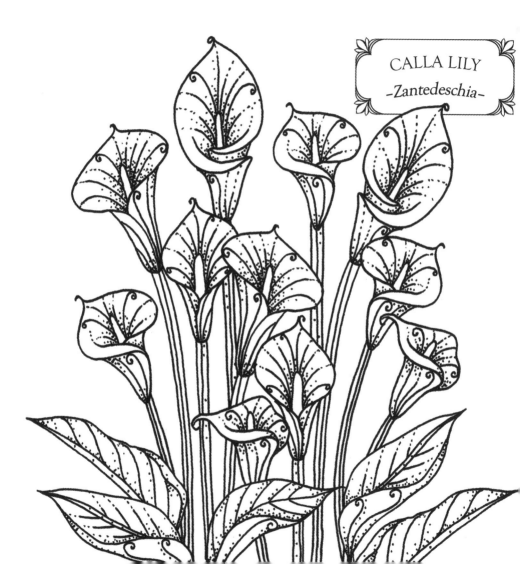

CALLA LILY

-Zantedeschia-

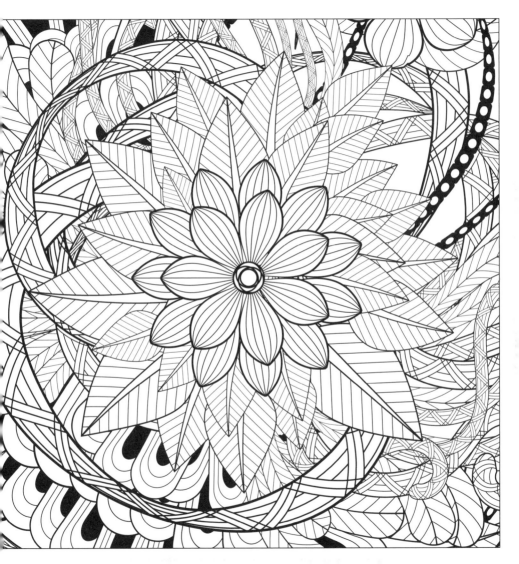

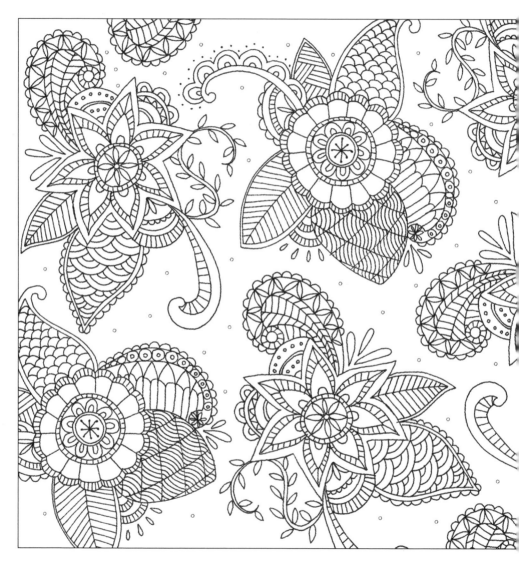

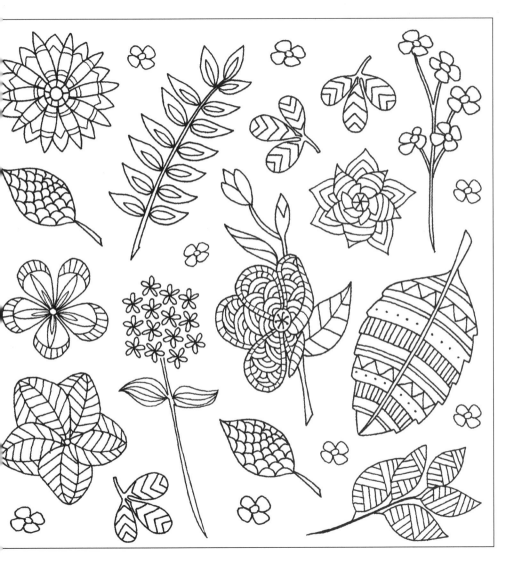

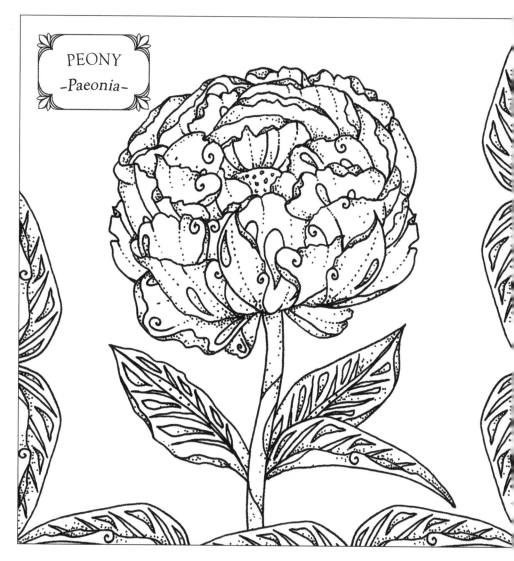

PEONY

-Paeonia-

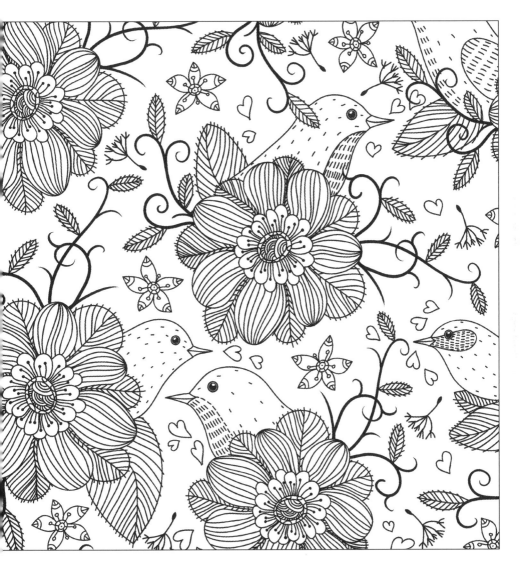

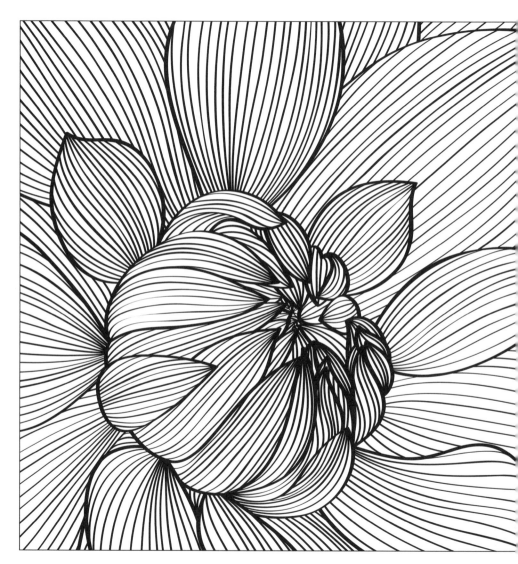

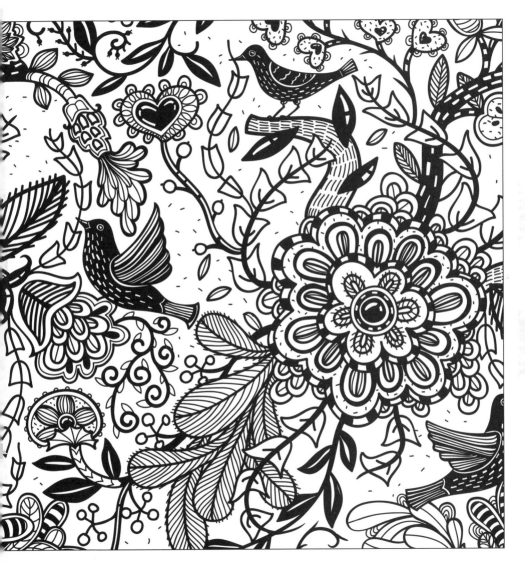

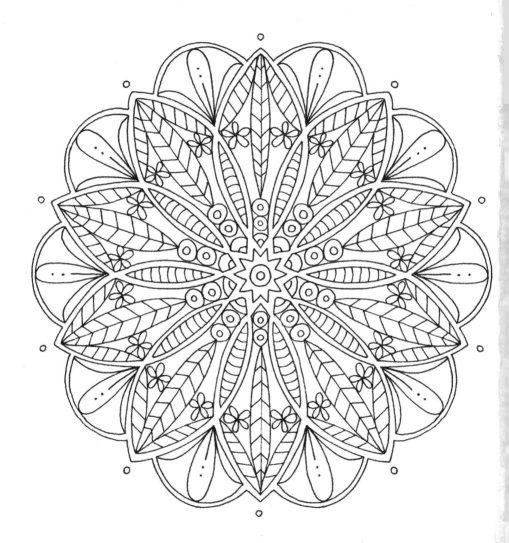